WHAT IS ANIMATION?

To **animate** means to bring life to something—in this case, a drawing of a cartoon character. (The character can be a person, an animal, or an inanimate object.) The process of animation involves drawing the character in **successive positions** to create **lifelike movement** such as a walk, a wave, a run, or a jump. An illusion of life is given to the drawings by including the character's **gestures** and **expressions**.

To bring the character to life, the animator first **analyzes** the action and then works out a sequence of moves (**"cycle"**) by drawing a number of planned poses (**"key drawings"**). The key poses that create the turning points of a movement are called the **"extremes."** When the extremes are combined with the other key poses and their **"in-betweens"** they make up a complete **action cycle**.

This book will introduce you to the basics of this animation process. Try animating some of the characters in this book, and then animate a character of your own. Then if you would like further information, see *Animation* and *Film Cartoons* by Preston Blair.

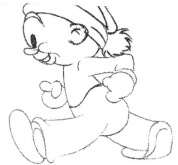

STUDY THE ACTION OF THE ELF CHARACTER ABOVE. THE SIXTEEN SEPARATE DRAWINGS MAKE UP A WALK CYCLE. THE CYCLE CAN BE REPEATED AS MANY TIMES AS NECESSARY TO CONTINUE THE ACTION.

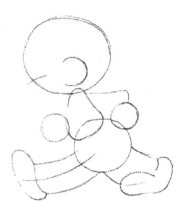

THE "FLIP BOOK"

A **flip book** is a series of pages in which successive drawings are laid on top of one another in close register. Each drawing is a **pose** from a sequence of positions that a character assumes to create a certain movement (e.g., a walk or a run) from beginning to end. This sequence of positions is known as a **cycle**. The number of poses in a cycle will vary depending on the action. The cycle should contain enough poses to keep the movement smooth throughout the action.

THE ACTION OF THIS LITTLE BEAR IS AN EIGHT-DRAWING CYCLE OF A RUN. TO MAKE QUICK ACTIONS LIKE THIS, SHORTER DRAWING CYCLES ARE USUALLY USED. NOTICE THE DIFFERENCE IN SPEED AND ACTION IN THE RUN AND THE WALK (ABOVE).

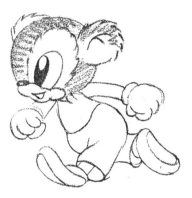

TO ANIMATE YOUR OWN CHARACTERS, CREATE AND TEST A SERIES OF "ROUGH" DRAWINGS. WHEN YOU ARE SATISFIED WITH THE ACTION AND MOVEMENTS IN THE CYCLE, ADD THE DETAILS. ONCE THE CYCLE OR ACTION IS "ROUGHED IN," RUN THROUGH THE DRAWINGS, IN "FLIP BOOK" FORM TO STUDY YOUR WORK.

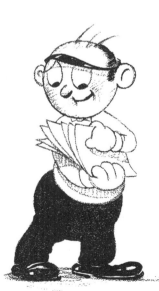

The sequence of drawings on the right side of the odd numbered pages in this book is an example of a "flip book" of action cycles. To observe the action, hold the book by the binding edge with your right hand as shown in the figure to the left, and then, with the outside edge between your left thumb and forefinger, flip through the pages quickly but separately. Start from the back of the book so that this is the last page you see.

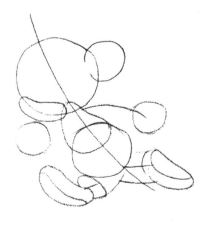

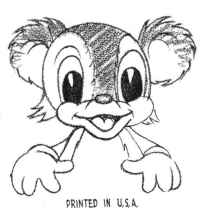

YOU WILL FIND THESE ACTION EXAMPLES MORE VALUABLE AS YOU PROGRESS. THIS CHARACTER WAS ANIMATED TO STUDY EXPRESSION AND SIMPLE CLOSEUP ACTION. THE MOUTH AND EYES CHANGE ALONG WITH THE POSITION OF THE HEAD. NOTICE THE WINK ON THE FINAL DRAWINGS.

CHARACTER CONSTRUCTION

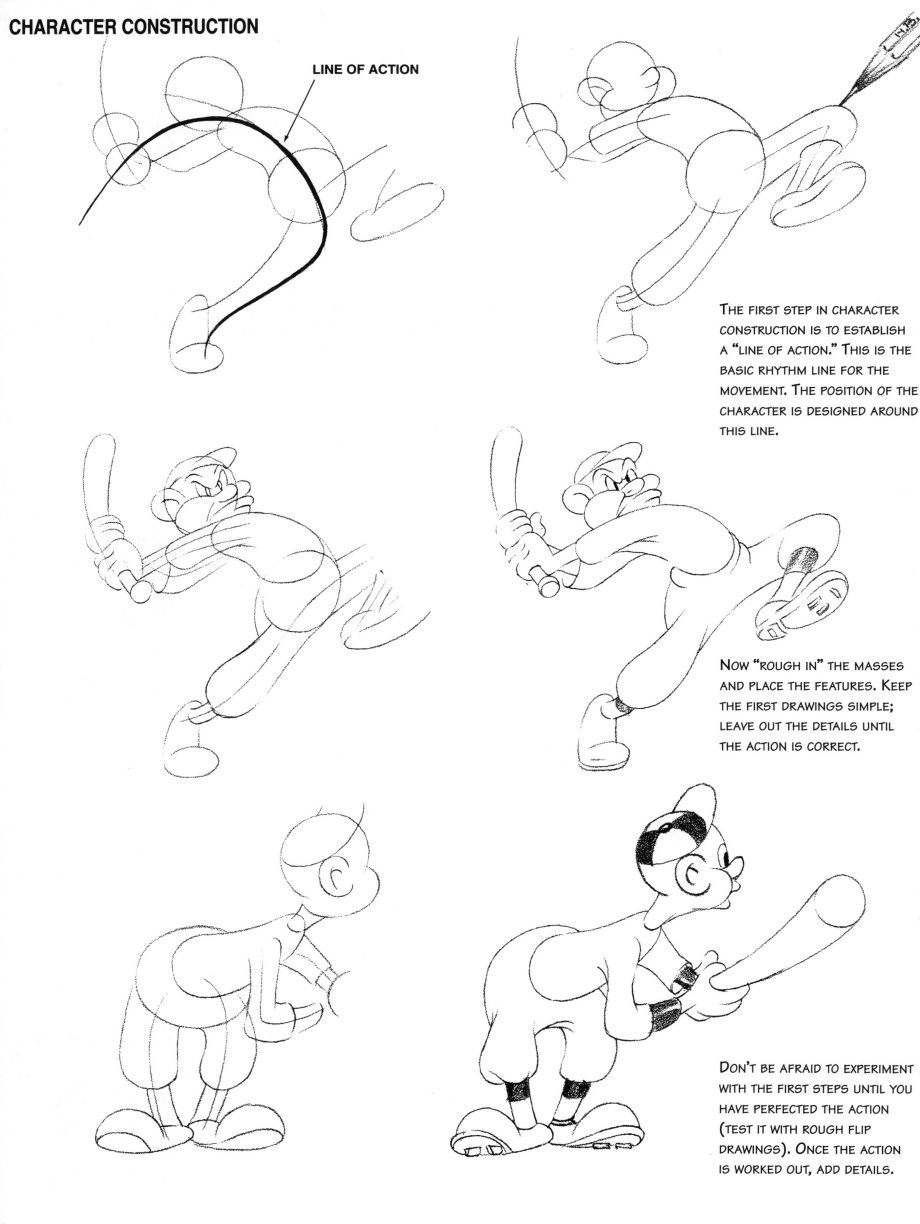

LINE OF ACTION

The first step in character construction is to establish a "line of action." This is the basic rhythm line for the movement. The position of the character is designed around this line.

Now "rough in" the masses and place the features. Keep the first drawings simple; leave out the details until the action is correct.

Don't be afraid to experiment with the first steps until you have perfected the action (test it with rough flip drawings). Once the action is worked out, add details.

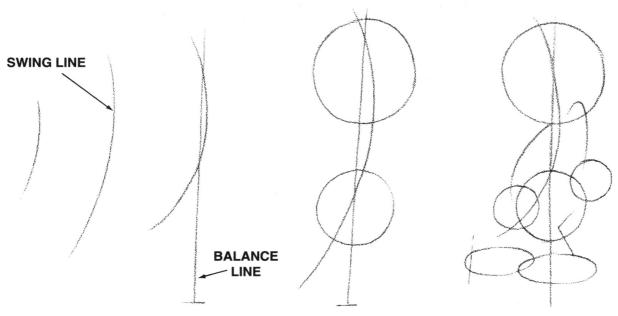

SWING LINE

BALANCE LINE

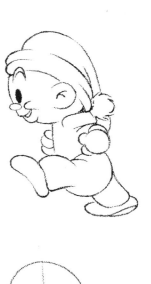

These examples will help you with the details of construction. Notice the swing and balance lines. The swing line establishes the major attitude of the character. The weight of the character should be equal on each side of the balance line unless the position is intentionally distorted.

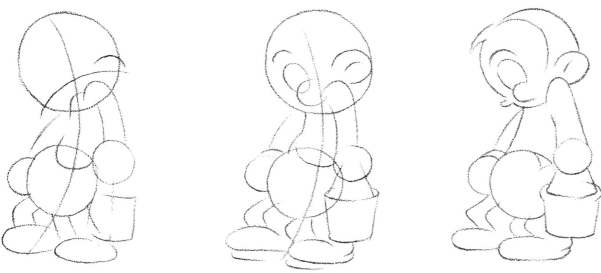

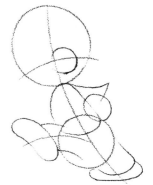

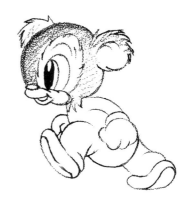

The basic construction for this figure consists of circles. The upper body is attached to the lower circle, creating a pear shape. Notice how the pose follows the action of the swing line. The straight left arm emphasizes the weight of the bucket.

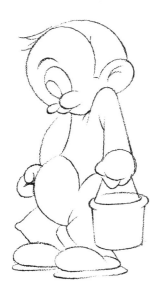 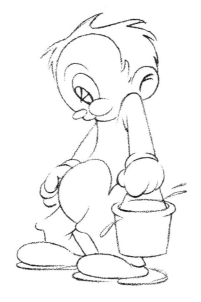 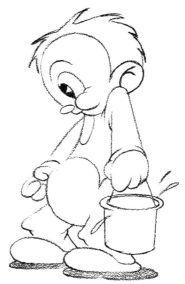

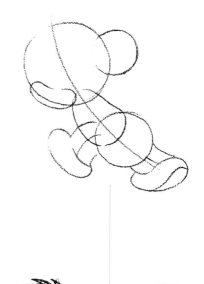

Once the "rough" is complete, clean up the details with one definite line. To make the action smooth and consistent, keep the lines on each consecutive drawing as uniform as possible (this prevents unwanted movement).

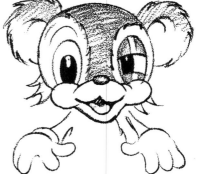

 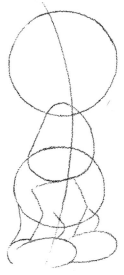 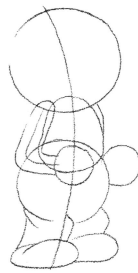

A "CUTE" CHARACTER HAS A LARGE HEAD, A SMALL BODY, AND SHORT LEGS. THE UPPER PART OF THE BODY IS USUALLY PEAR-SHAPED. THE CHARACTER ABOVE APPEARS SLIGHTLY MORE "DUMPY" IN FORM THAN THE CHARACTER BELOW. THIS DIFFERENCE GIVES EACH CHARACTER ITS OWN PERSONALITY.

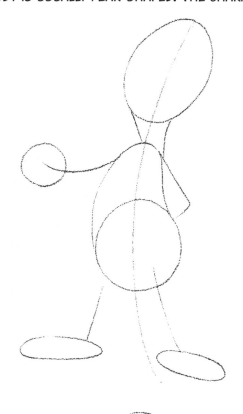

TO DRAW THIS CHARACTER, BEGIN WITH THE LINE OF ACTION. THEN DRAW THE ROUGH FORMS OF THE HEAD, THE NECK, AND THE REST OF THE BODY. PLACE THE PARTS COMFORTABLY ON THE LINE SO THE FIGURE DOES NOT APPEAR TO BE OFF

START LAYING IN THE OUTLINE SHAPES OF THE HAT, BAG, AND CLUBS, ALONG WITH THE ROUGH DETAILS OF THE FIGURE.

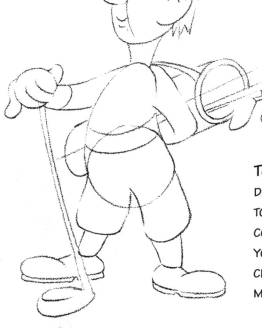

TO COMPLETE THE FIGURE, DRAW THE DETAILS. PAY PARTICULAR ATTENTION TO THE CAST SHADOWS; KEEP THEM CONSISTENT IN ALL DRAWINGS. WHEN YOU ARE SATISFIED WITH THE FIGURE, CLEAN UP ANY UNWANTED PENCIL MARKS, AND THEN SHADE.

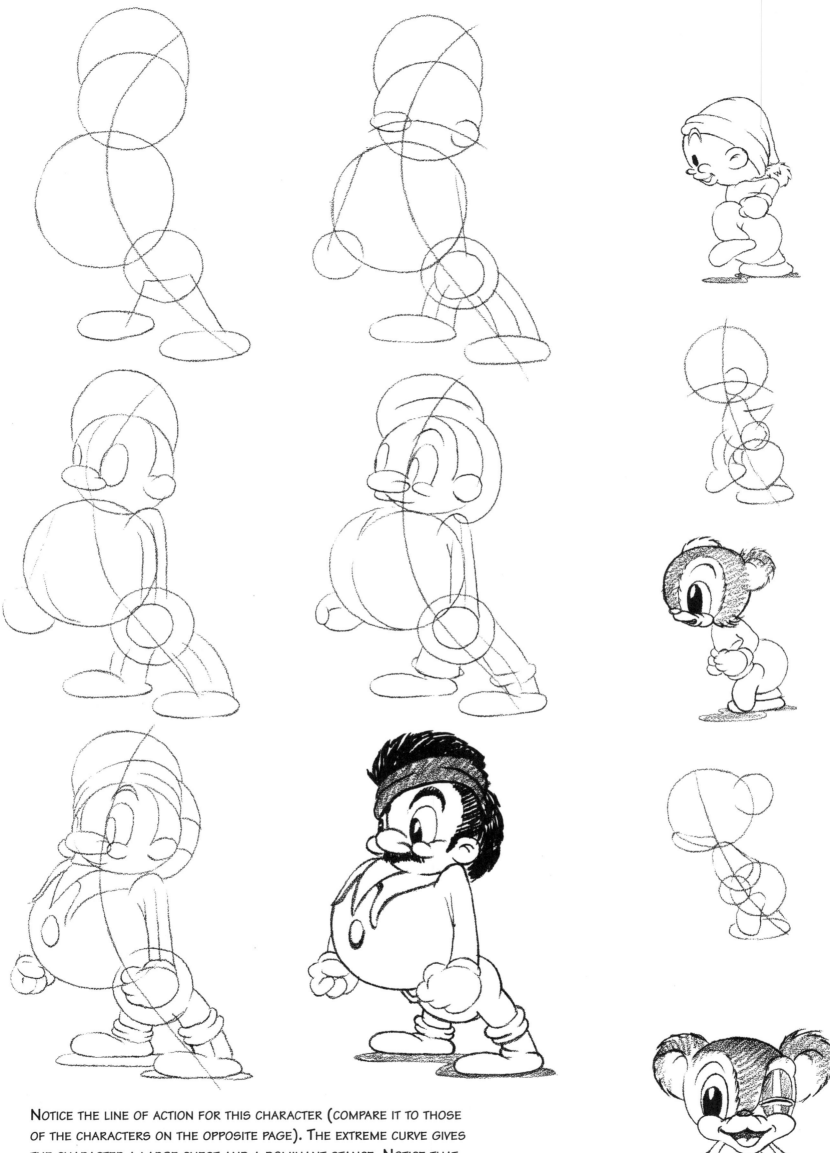

NOTICE THE LINE OF ACTION FOR THIS CHARACTER (COMPARE IT TO THOSE OF THE CHARACTERS ON THE OPPOSITE PAGE). THE EXTREME CURVE GIVES THE CHARACTER A LARGE CHEST AND A DOMINANT STANCE. NOTICE THAT THE RIGHT LEG COUNTER-BALANCES THE FORWARD LEAN. THE LARGE CHEST AND SMALL HIPS CREATE A TYPICAL BRAGGART TYPE.

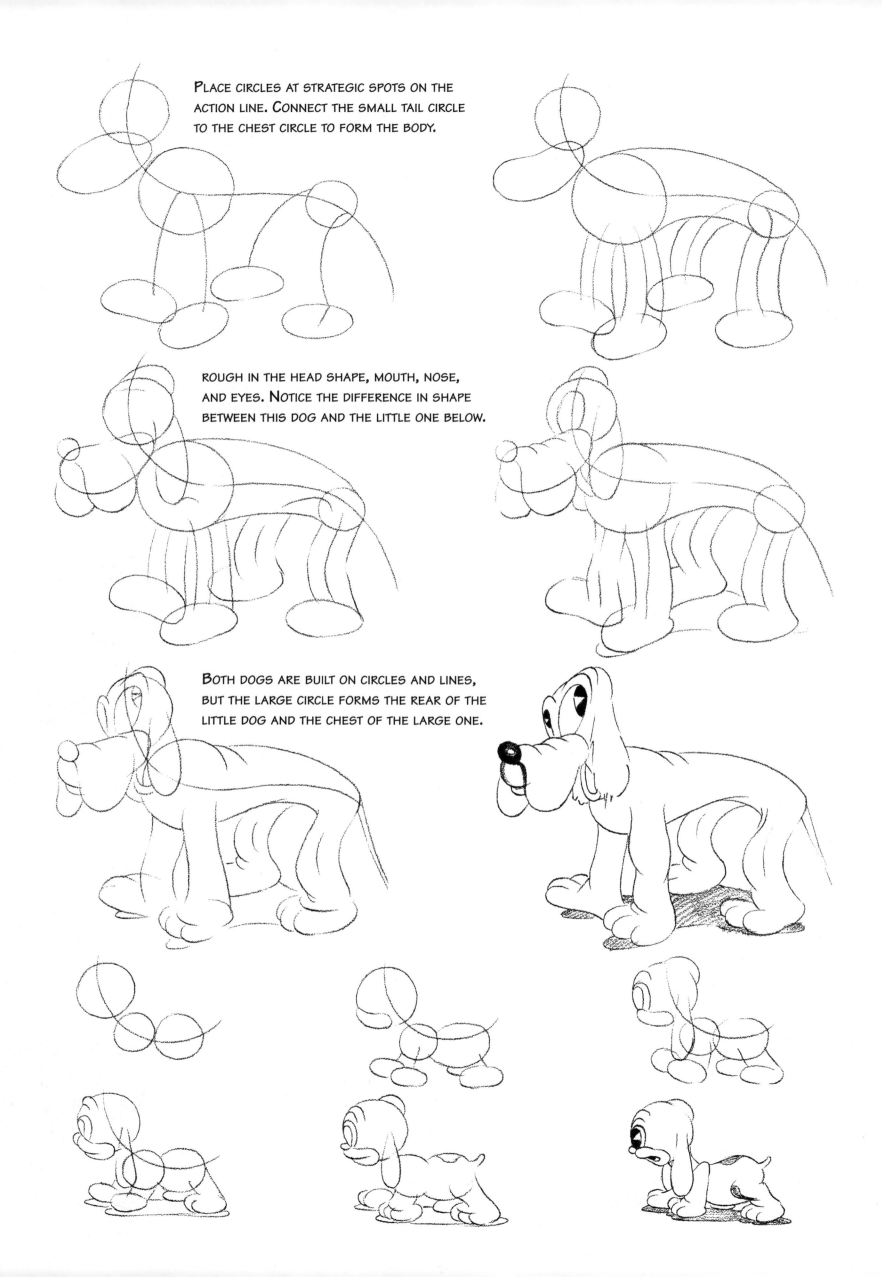

PLACE CIRCLES AT STRATEGIC SPOTS ON THE
ACTION LINE. CONNECT THE SMALL TAIL CIRCLE
TO THE CHEST CIRCLE TO FORM THE BODY.

ROUGH IN THE HEAD SHAPE, MOUTH, NOSE,
AND EYES. NOTICE THE DIFFERENCE IN SHAPE
BETWEEN THIS DOG AND THE LITTLE ONE BELOW.

BOTH DOGS ARE BUILT ON CIRCLES AND LINES,
BUT THE LARGE CIRCLE FORMS THE REAR OF THE
LITTLE DOG AND THE CHEST OF THE LARGE ONE.

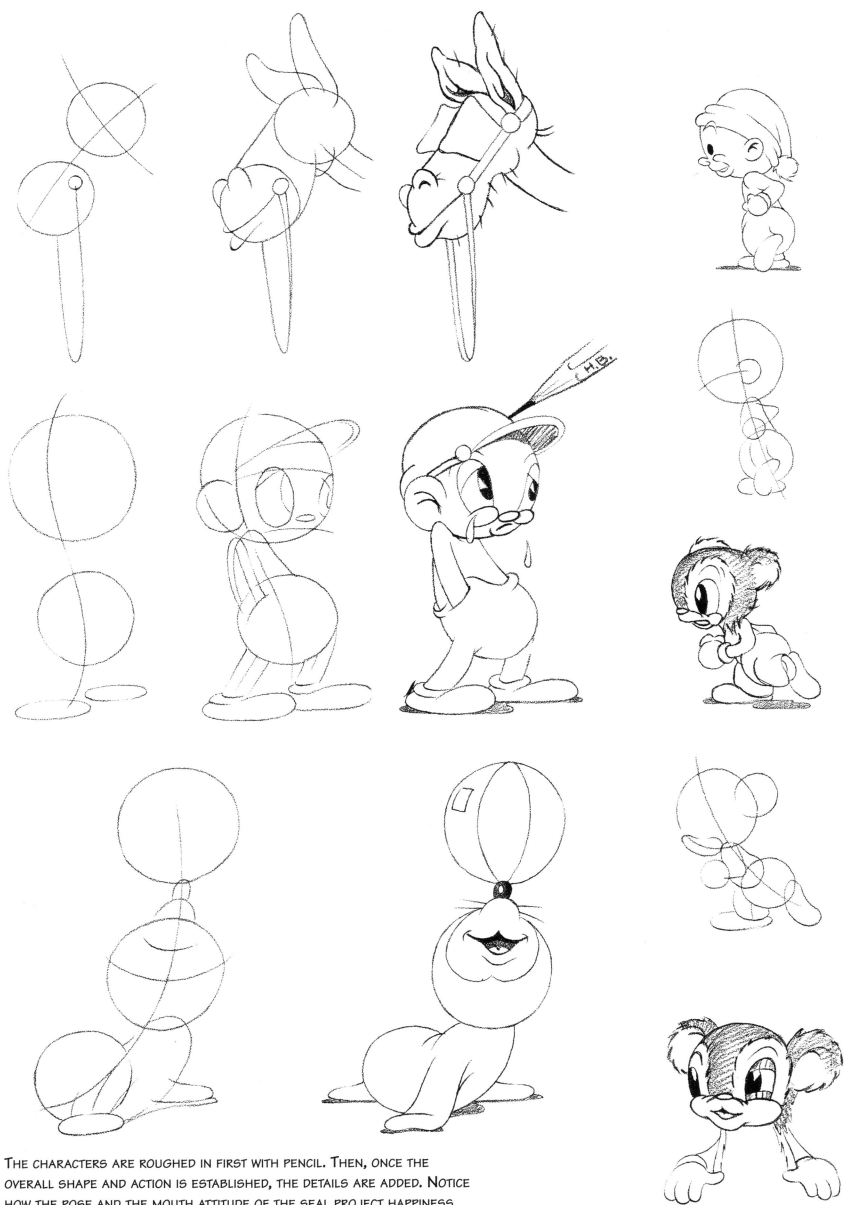

THE CHARACTERS ARE ROUGHED IN FIRST WITH PENCIL. THEN, ONCE THE
OVERALL SHAPE AND ACTION IS ESTABLISHED, THE DETAILS ARE ADDED. NOTICE
HOW THE POSE AND THE MOUTH ATTITUDE OF THE SEAL PROJECT HAPPINESS.

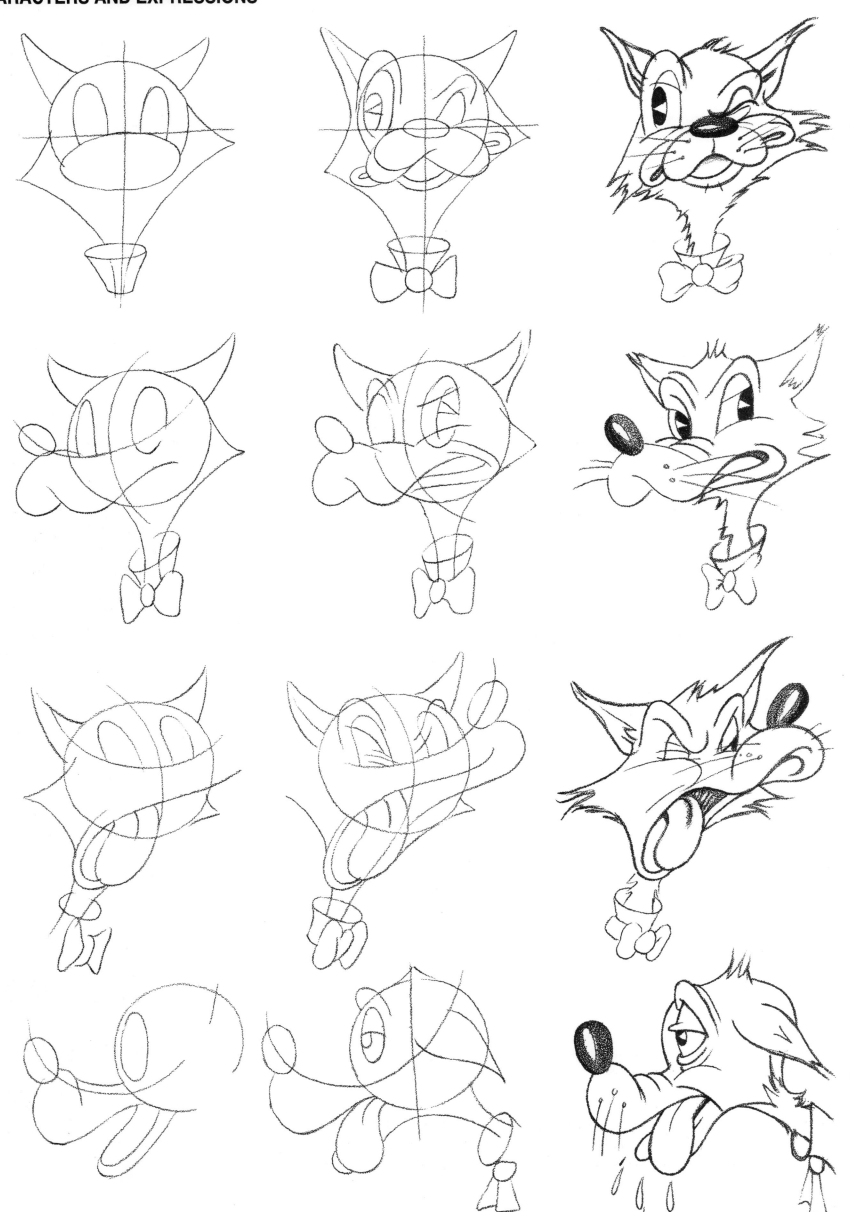

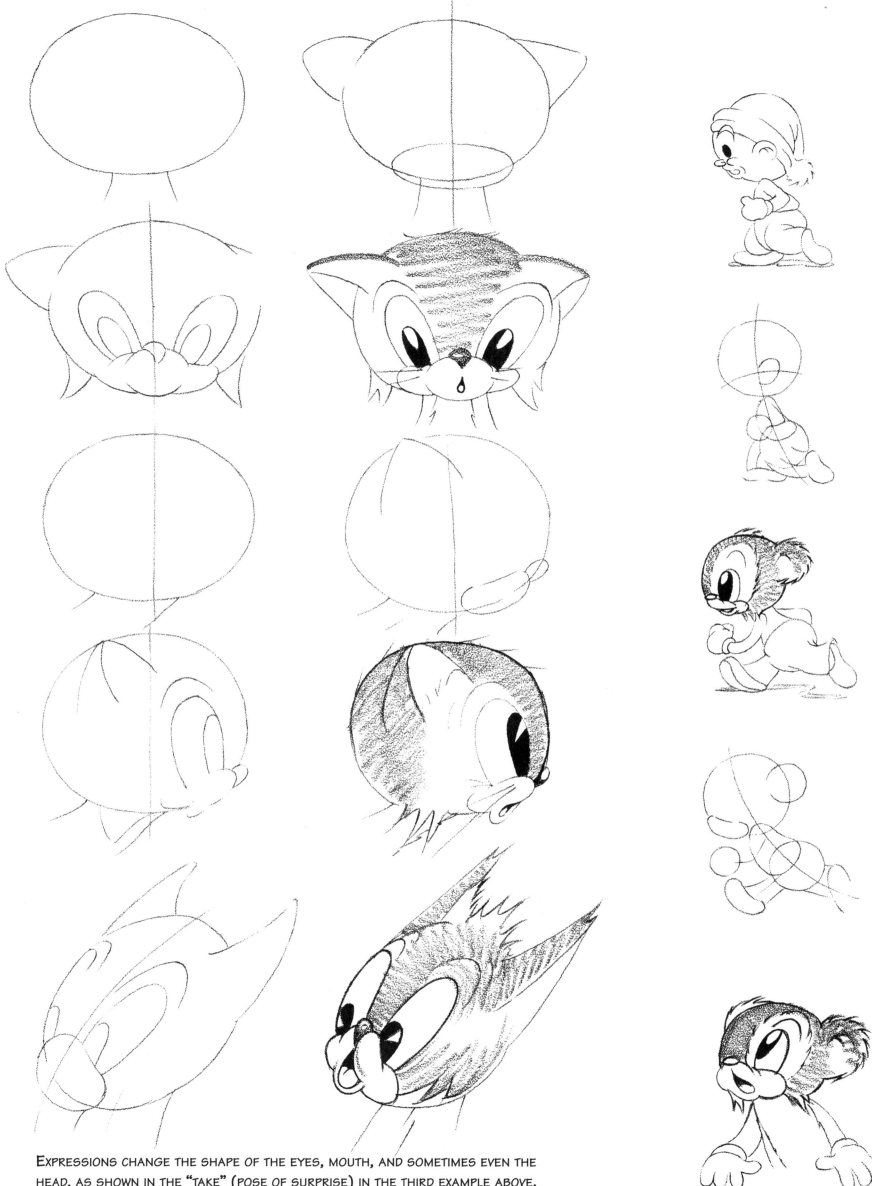

EXPRESSIONS CHANGE THE SHAPE OF THE EYES, MOUTH, AND SOMETIMES EVEN THE HEAD, AS SHOWN IN THE "TAKE" (POSE OF SURPRISE) IN THE THIRD EXAMPLE ABOVE. PRACTICE DRAWING THESE EXPRESSIONS, AND THEN DRAW SOME DESIGNS OF YOUR OWN.

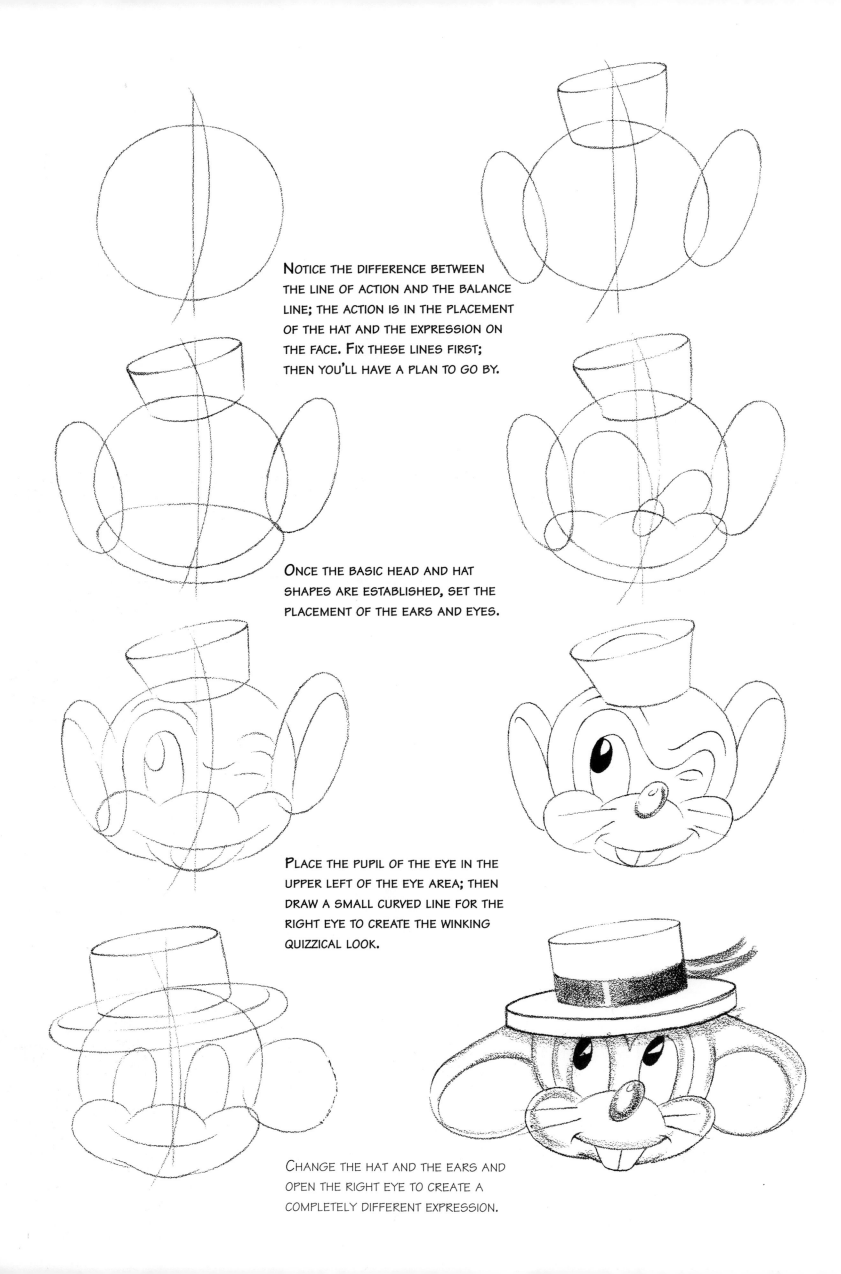

NOTICE THE DIFFERENCE BETWEEN THE LINE OF ACTION AND THE BALANCE LINE; THE ACTION IS IN THE PLACEMENT OF THE HAT AND THE EXPRESSION ON THE FACE. FIX THESE LINES FIRST; THEN YOU'LL HAVE A PLAN TO GO BY.

ONCE THE BASIC HEAD AND HAT SHAPES ARE ESTABLISHED, SET THE PLACEMENT OF THE EARS AND EYES.

PLACE THE PUPIL OF THE EYE IN THE UPPER LEFT OF THE EYE AREA; THEN DRAW A SMALL CURVED LINE FOR THE RIGHT EYE TO CREATE THE WINKING QUIZZICAL LOOK.

CHANGE THE HAT AND THE EARS AND OPEN THE RIGHT EYE TO CREATE A COMPLETELY DIFFERENT EXPRESSION.

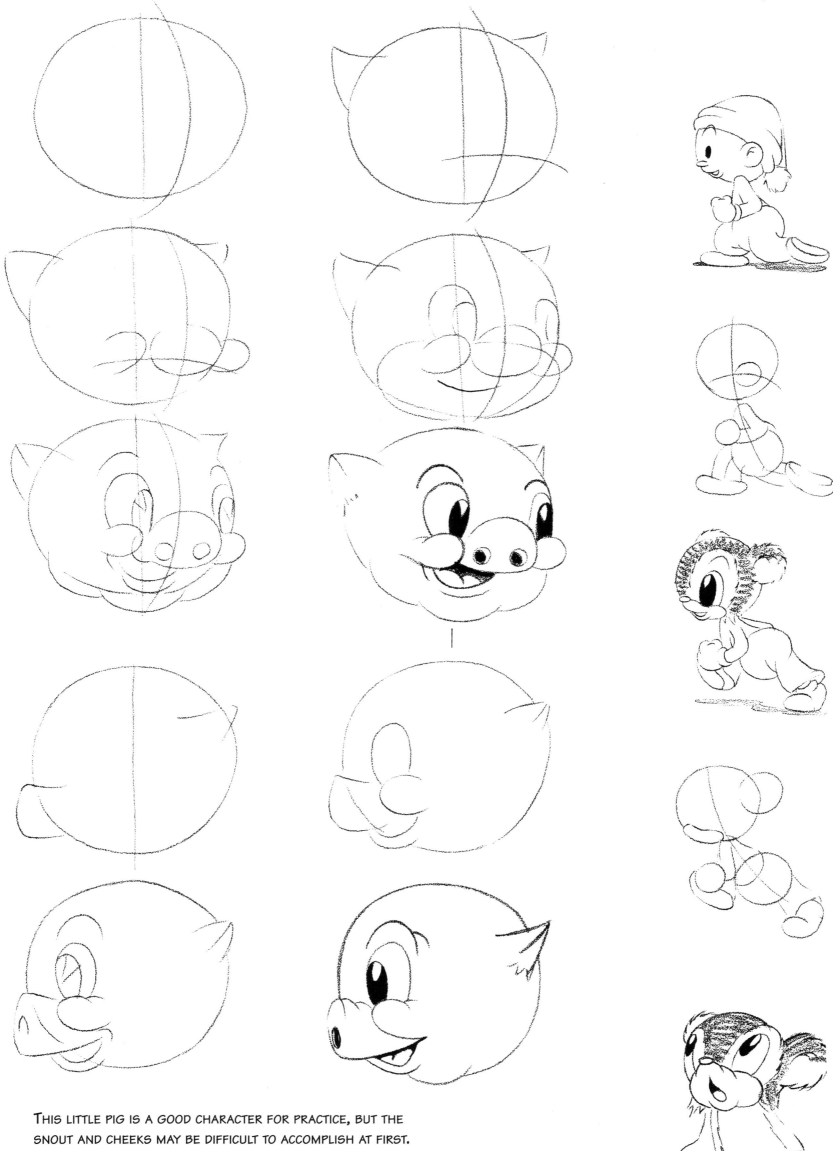

THIS LITTLE PIG IS A GOOD CHARACTER FOR PRACTICE, BUT THE SNOUT AND CHEEKS MAY BE DIFFICULT TO ACCOMPLISH AT FIRST. MOVE THEM AROUND TO CHANGE THE PIG'S EXPRESSION.

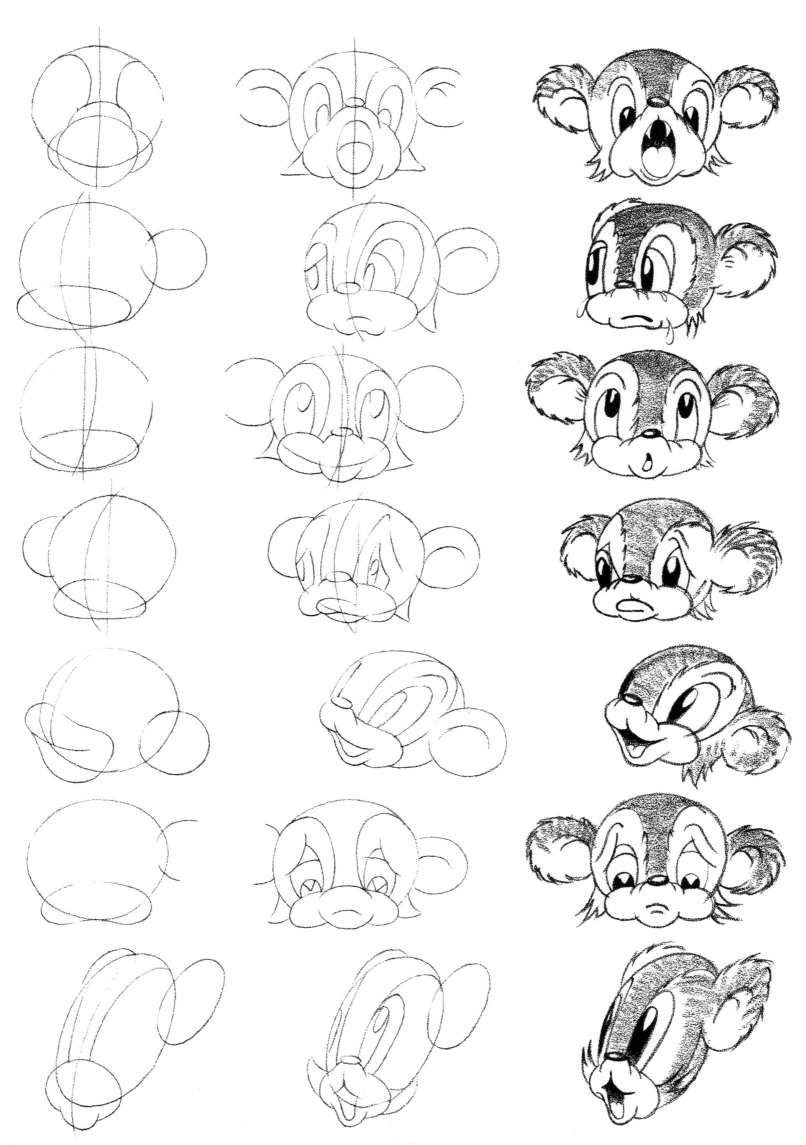

STUDY EACH OF THESE HEADS CAREFULLY; NOTICE HOW THE TILT OF THE HEAD, THE EYES, AND THE MOUTH CREATE THE DESIRED EXPRESSION. PRACTICE BY MAKING FACES IN MIRROR AND DRAWING WHAT YOU SEE.

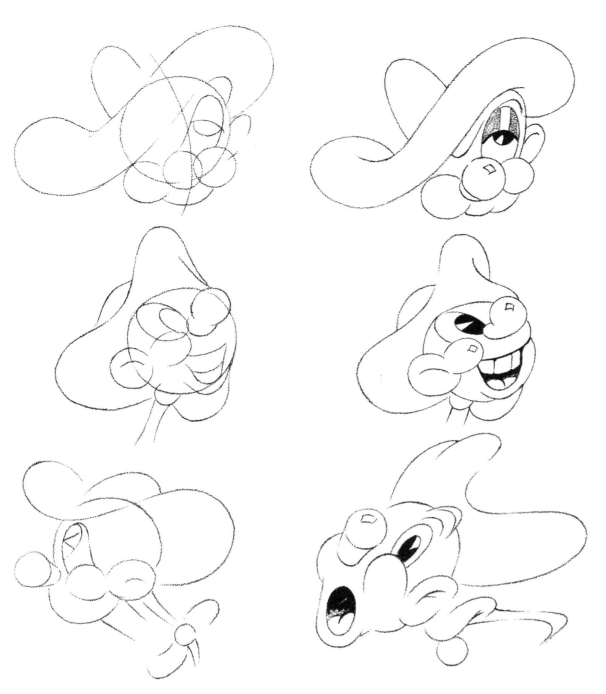

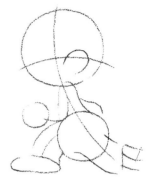

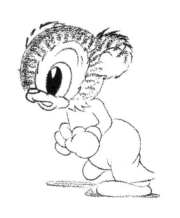

STUDY THE DEVELOPMENT OF THESE EXPRESSIONS, AND THEN TRY TO WORK OUT SOME EXPRESSIONS OF YOUR OWN. ADD HANDS AND PROPS TO HELP PROJECT THE CHARACTER, AS SHOWN BELOW.

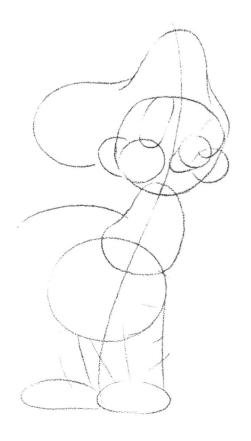

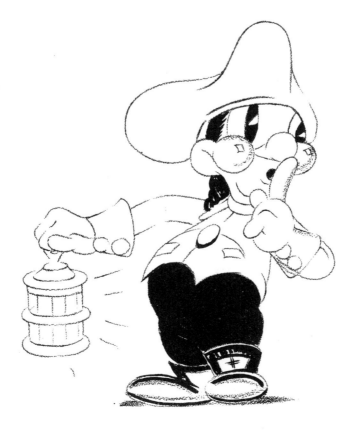

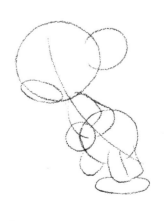

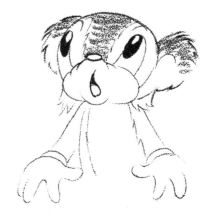

CARTOON HAND CONSTRUCTION

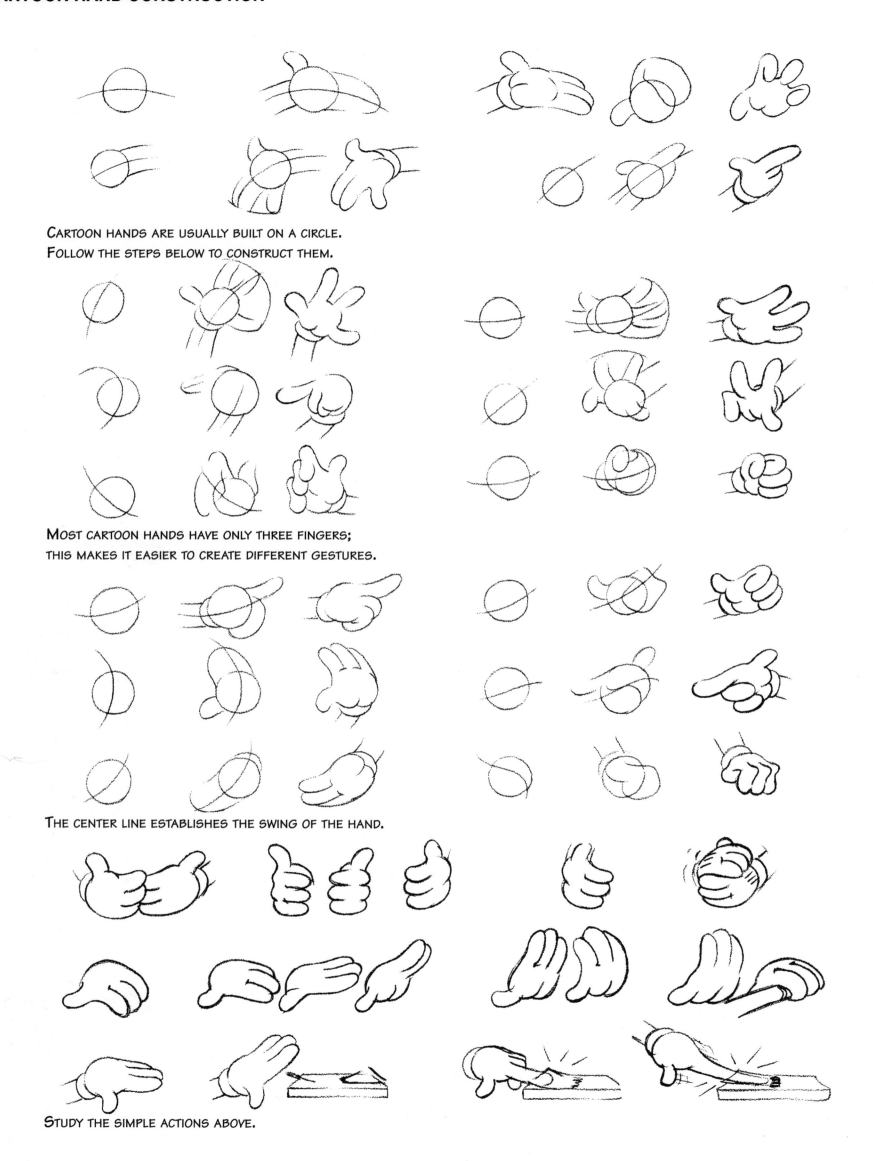

CARTOON HANDS ARE USUALLY BUILT ON A CIRCLE.
FOLLOW THE STEPS BELOW TO CONSTRUCT THEM.

MOST CARTOON HANDS HAVE ONLY THREE FINGERS;
THIS MAKES IT EASIER TO CREATE DIFFERENT GESTURES.

THE CENTER LINE ESTABLISHES THE SWING OF THE HAND.

STUDY THE SIMPLE ACTIONS ABOVE.

CARTOON FOOT CONSTRUCTION

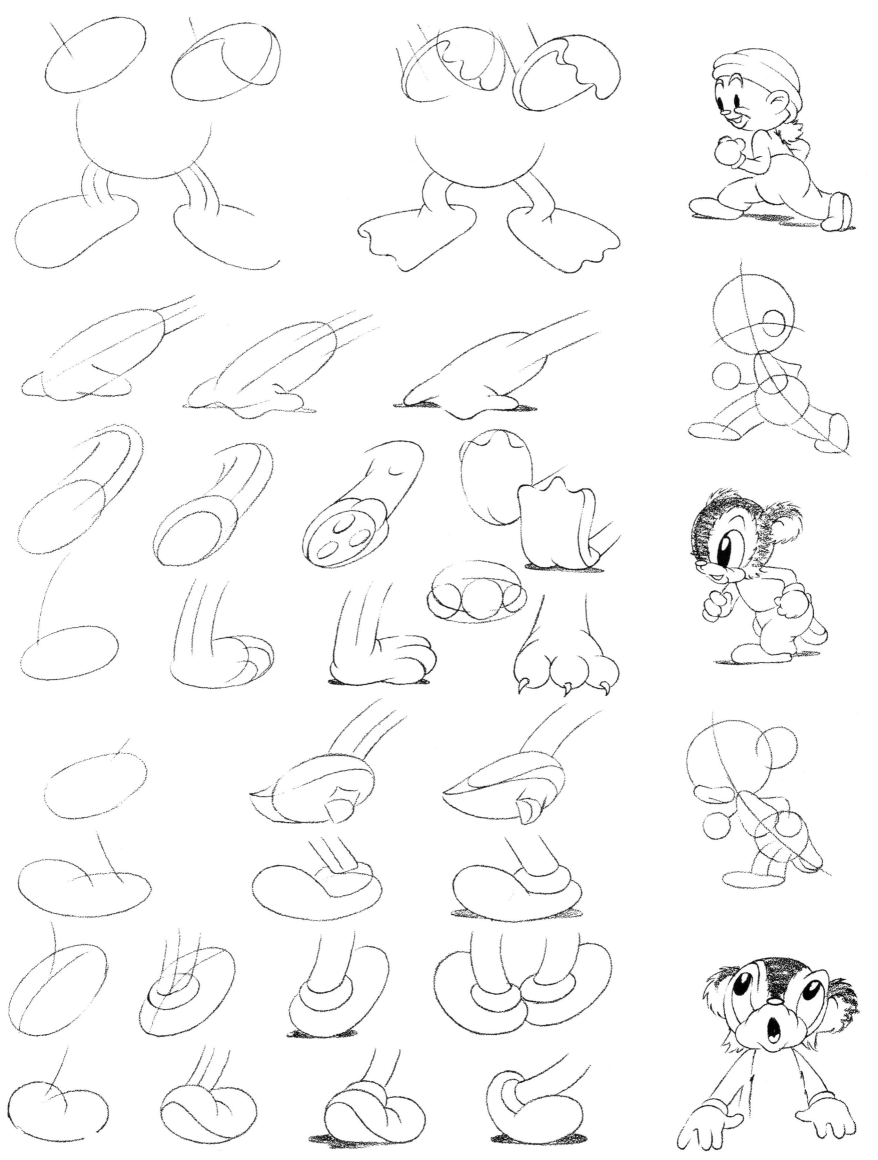

STUDY THE CONSTRUCTION OF THESE FEET. THE CAST SHADOWS ANCHOR THE CHARACTERS TO THE GROUND.

MORE CHARACTERS AND EXPRESSIONS

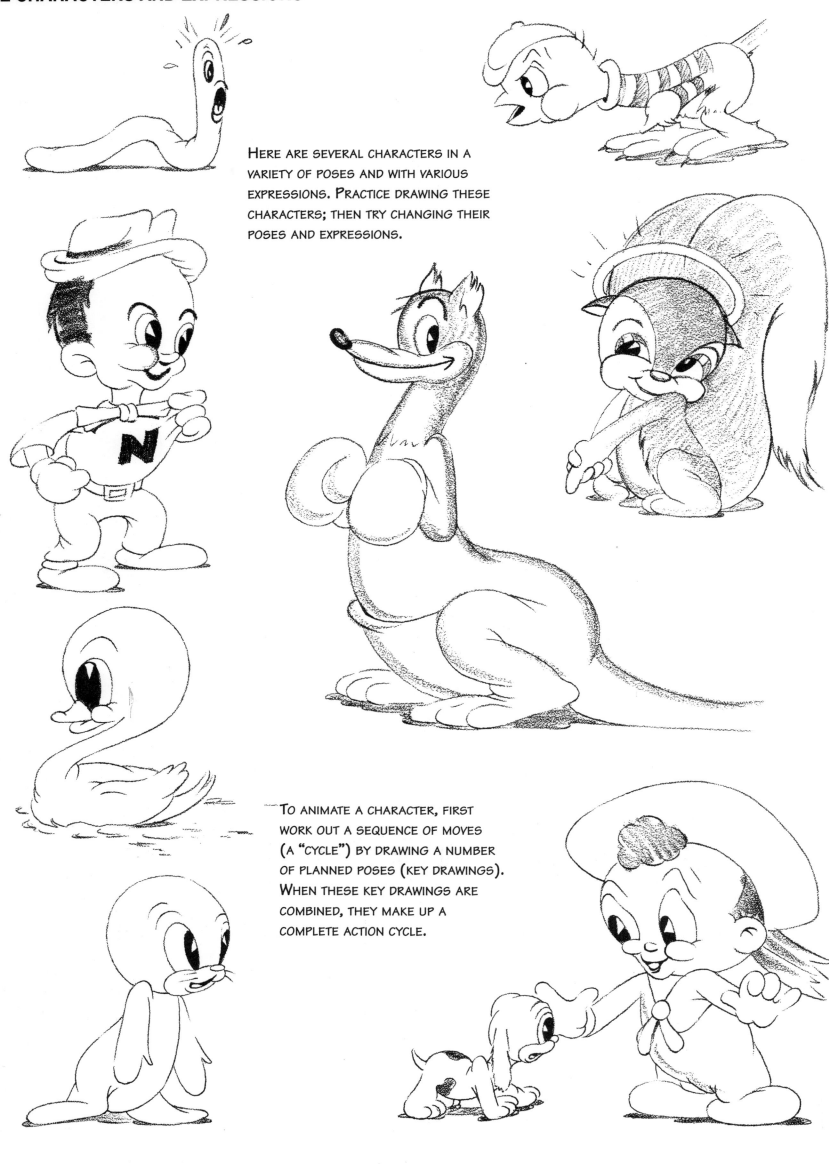

HERE ARE SEVERAL CHARACTERS IN A VARIETY OF POSES AND WITH VARIOUS EXPRESSIONS. PRACTICE DRAWING THESE CHARACTERS; THEN TRY CHANGING THEIR POSES AND EXPRESSIONS.

TO ANIMATE A CHARACTER, FIRST WORK OUT A SEQUENCE OF MOVES (A "CYCLE") BY DRAWING A NUMBER OF PLANNED POSES (KEY DRAWINGS). WHEN THESE KEY DRAWINGS ARE COMBINED, THEY MAKE UP A COMPLETE ACTION CYCLE.

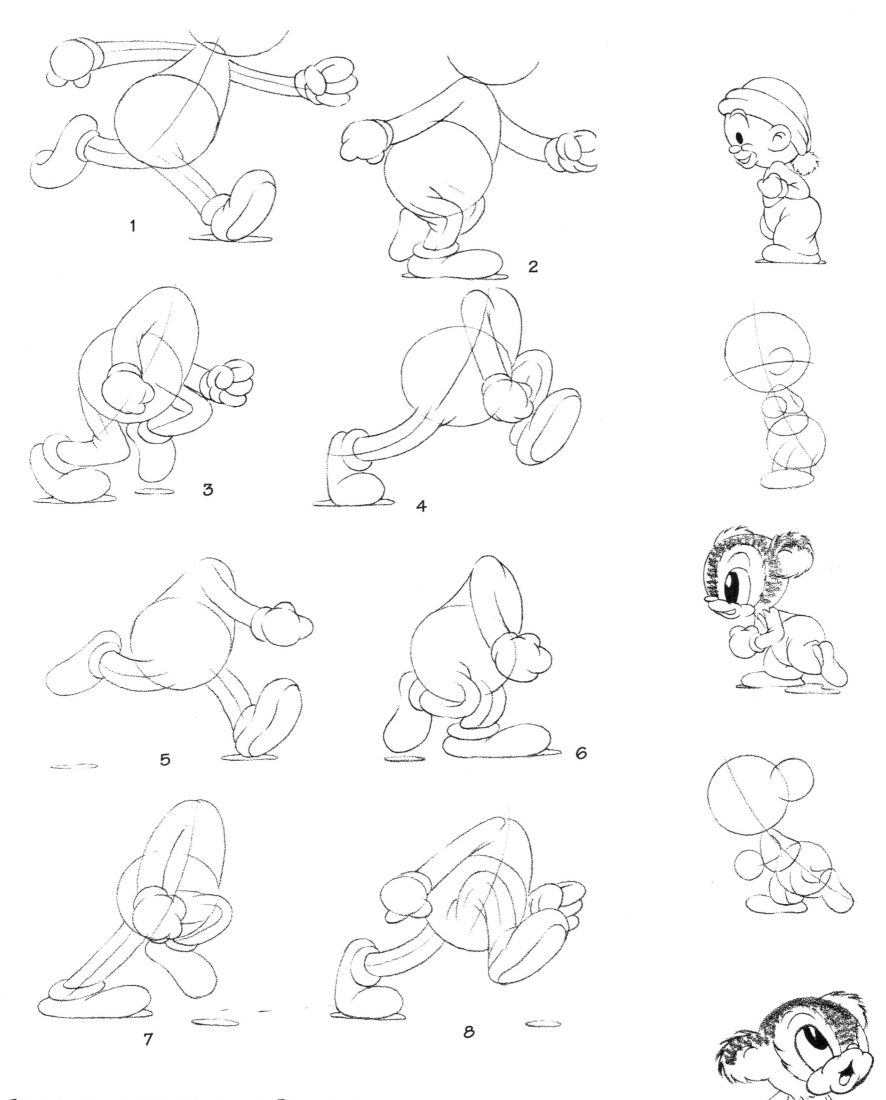

1

2

3

4

5

6

7

8

THIS IS AN EIGHT-DRAWING CYCLE OF A RUN. DRAWING ONE FOLLOWS
DRAWING EIGHT TO COMPLETE THE CYCLE AND START THE REPEAT. THIS
IS A VERY FAST RUN; A SLOWER ACTION WOULD NEED MORE DRAWINGS.

EXTREMES

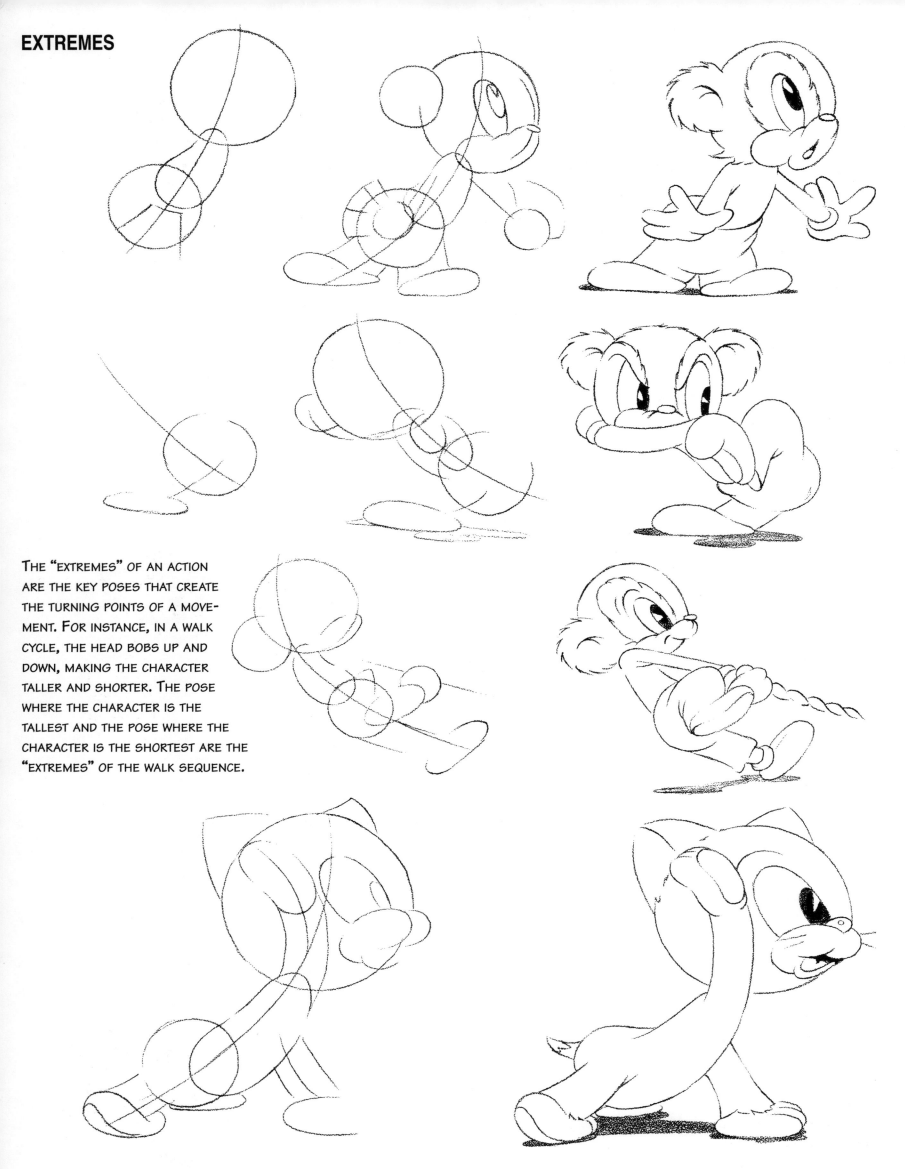

The "extremes" of an action are the key poses that create the turning points of a movement. For instance, in a walk cycle, the head bobs up and down, making the character taller and shorter. The pose where the character is the tallest and the pose where the character is the shortest are the "extremes" of the walk sequence.

Study the drawings on these two pages; they will help you develop "extreme" positions for your own characters.

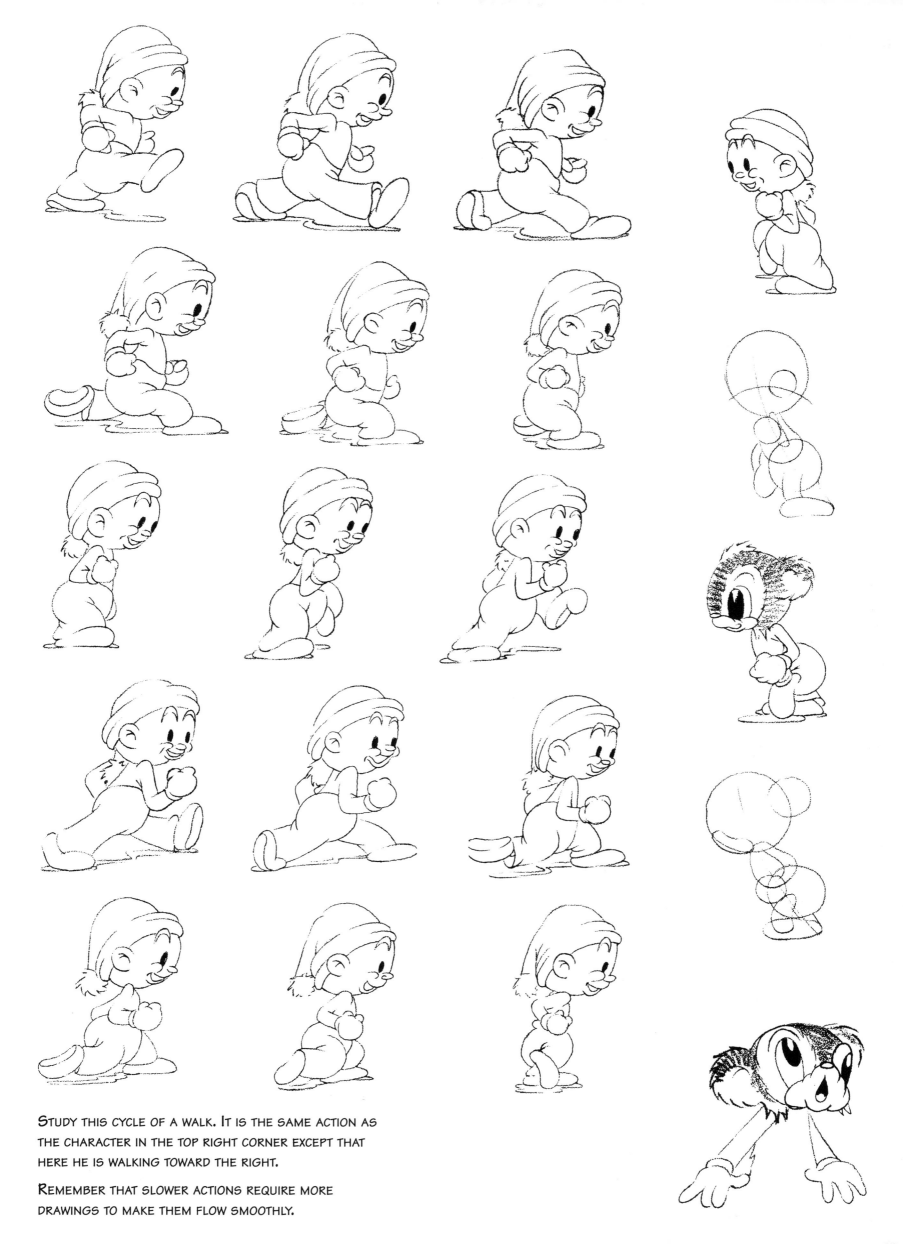

STUDY THIS CYCLE OF A WALK. IT IS THE SAME ACTION AS THE CHARACTER IN THE TOP RIGHT CORNER EXCEPT THAT HERE HE IS WALKING TOWARD THE RIGHT.

REMEMBER THAT SLOWER ACTIONS REQUIRE MORE DRAWINGS TO MAKE THEM FLOW SMOOTHLY.

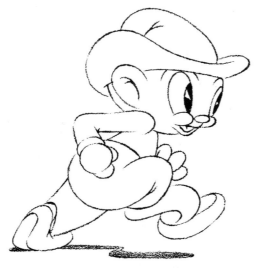 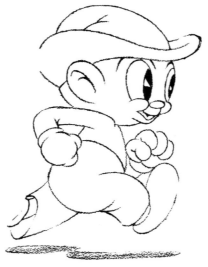 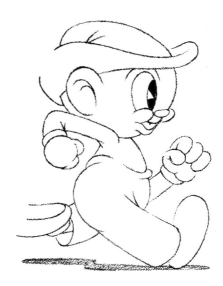

THIS IS A TWELVE-DRAWING CYCLE OF A RUN ACTION. THIS RUN IS NOT AS FAST AS THE ONE ON PAGE **17**; THERE ARE MORE STEP DRAWINGS TO THIS ONE. THE LAST DRAWING IS FOLLOWED BY THE FIRST TO CONTINUE THE ACTION.

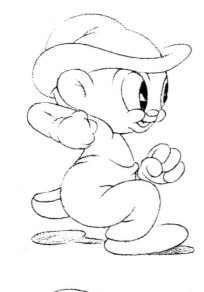 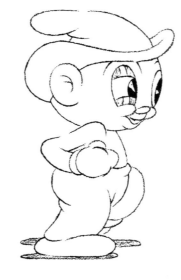 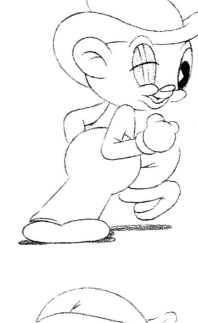

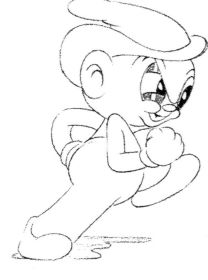 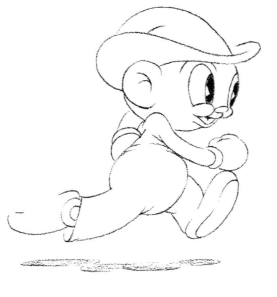 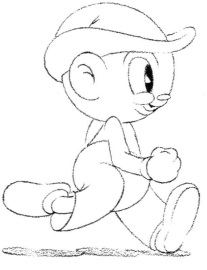

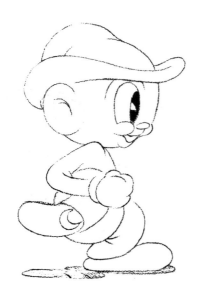 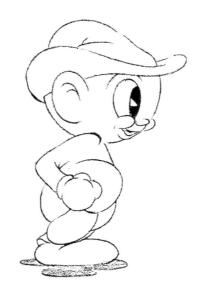 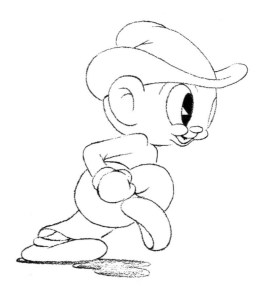

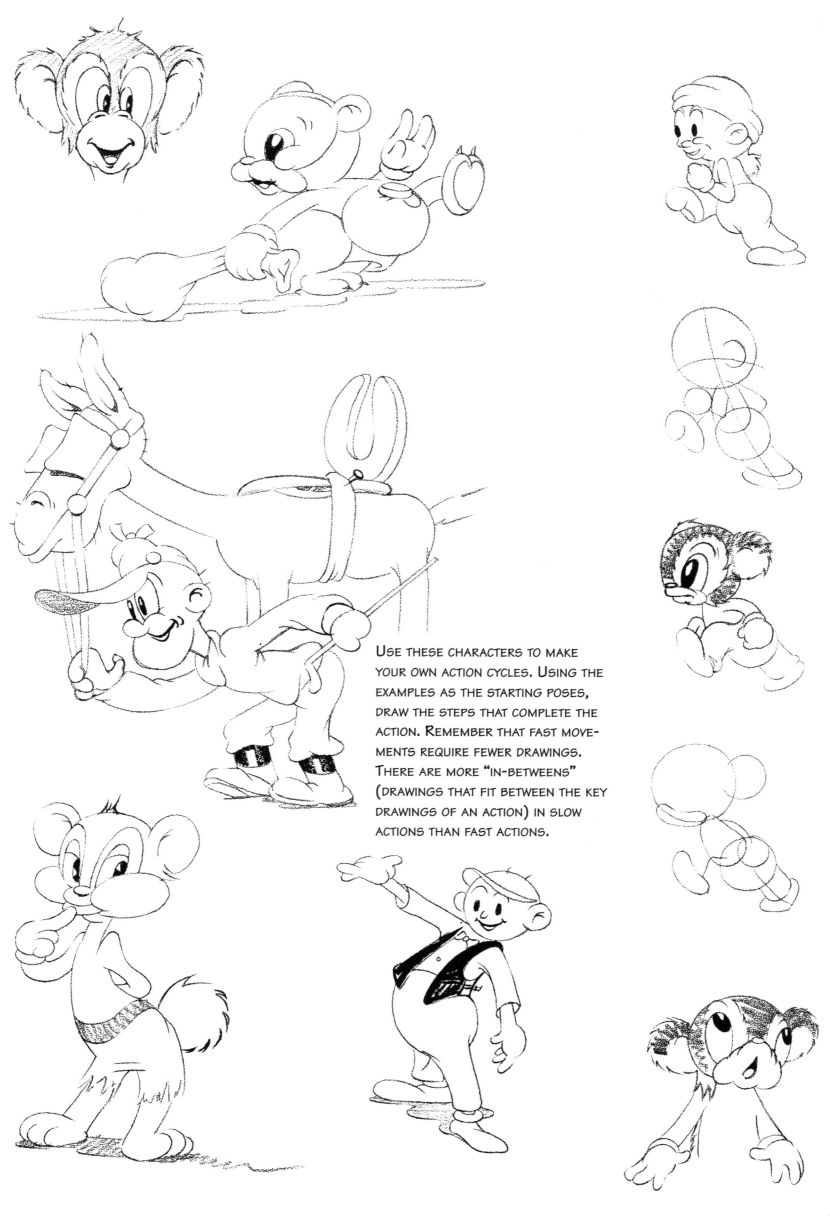

Use these characters to make your own action cycles. Using the examples as the starting poses, draw the steps that complete the action. Remember that fast movements require fewer drawings. There are more "in-betweens" (drawings that fit between the key drawings of an action) in slow actions than fast actions.

 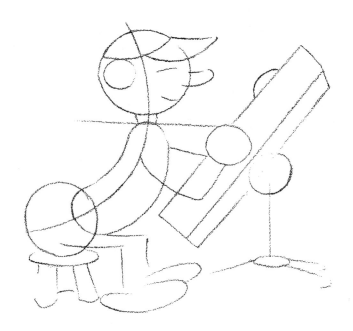

Thus far, this book has been devoted mostly to character analysis and construction with some emphasis on movement. For this type of work, the only materials needed are pencil, paper, and a plain drawing board or flat surface. However, for in-depth study of action and movement, an animation board (or "light box") is needed. An animation board consists of a lighted glass surface with two brass pegs attached for pinning the drawings in place. To use the animation board, your drawing paper must be punched at the top to fit snugly over the brass pegs.

First visualize the action, and then draw a key pose, or "extreme." Then place a blank sheet of paper over the first drawing, and draw the next extreme, using the first drawing for reference (the light under the plate glass allows you to see through both sheets of paper). Keep making extreme drawings, using the preceding drawings for reference, until the action is complete. The animation board will allow you to study the action of the character and then change the parts of the character as much or as little as needed to make it work.

Once the extremes are roughed in, use the animation board to draw the in-betweens to tie the action together. Slow down the movement by adding more in-betweens; speed the action by drawing fewer in-betweens.

 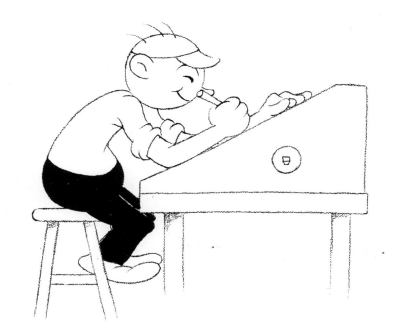

PAN ACTIONS

Another way to create movement—or an illusion of movement—is with a "pan" action. Pan actions involve rolling the background past the character while the character remains in one place. The rolling background makes the character appear as if it is moving. If your action calls for the use of a "pan," plan the speed of the background to coordinate with the character movement so the feet and the ground move together.

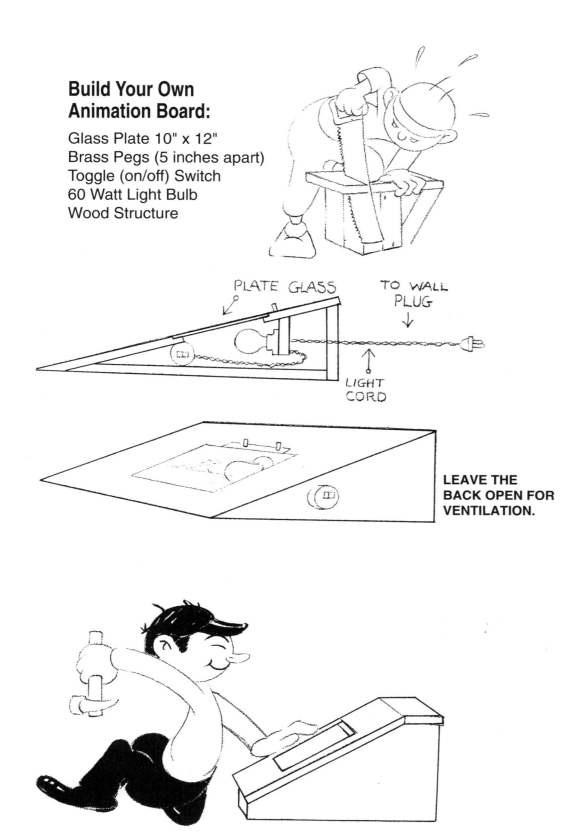

Build Your Own Animation Board:

Glass Plate 10" x 12"
Brass Pegs (5 inches apart)
Toggle (on/off) Switch
60 Watt Light Bulb
Wood Structure

PLATE GLASS

TO WALL PLUG

LIGHT CORD

LEAVE THE BACK OPEN FOR VENTILATION.

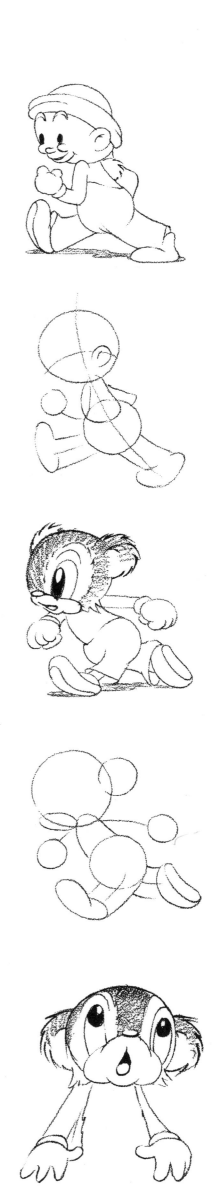

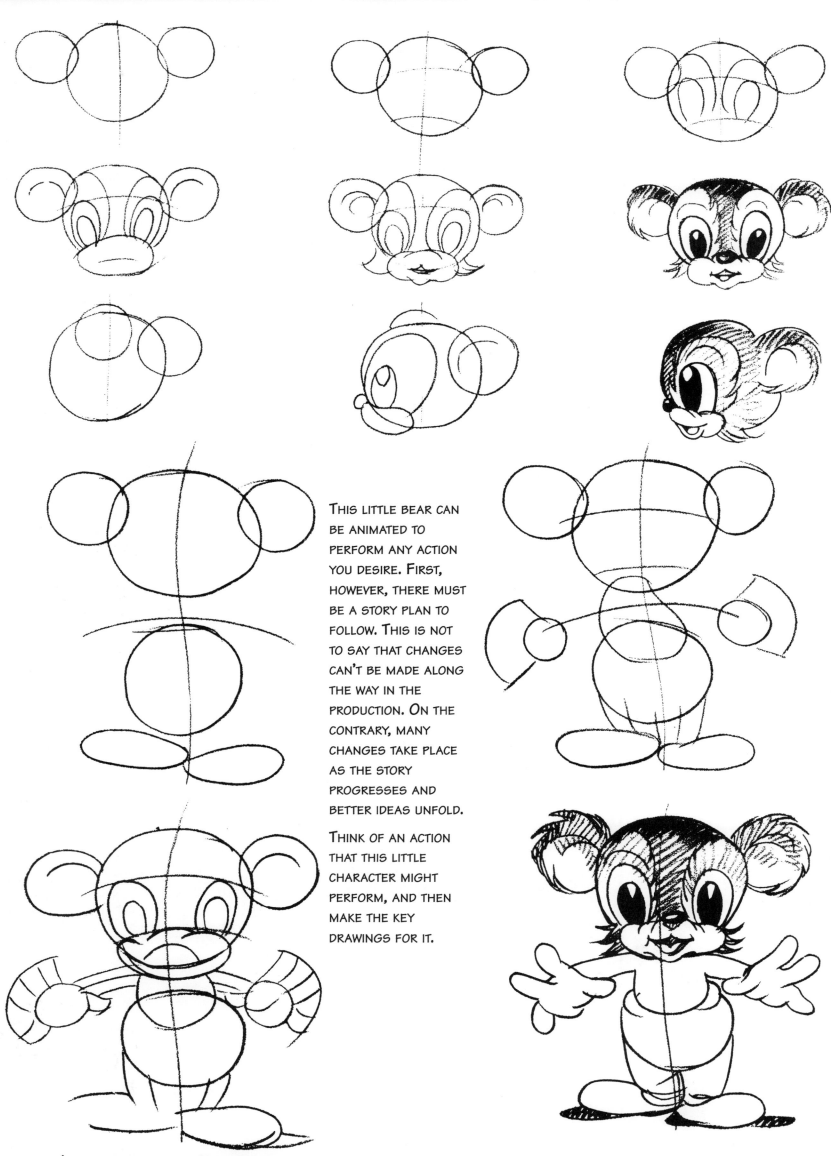

THIS LITTLE BEAR CAN BE ANIMATED TO PERFORM ANY ACTION YOU DESIRE. FIRST, HOWEVER, THERE MUST BE A STORY PLAN TO FOLLOW. THIS IS NOT TO SAY THAT CHANGES CAN'T BE MADE ALONG THE WAY IN THE PRODUCTION. ON THE CONTRARY, MANY CHANGES TAKE PLACE AS THE STORY PROGRESSES AND BETTER IDEAS UNFOLD.

THINK OF AN ACTION THAT THIS LITTLE CHARACTER MIGHT PERFORM, AND THEN MAKE THE KEY DRAWINGS FOR IT.

AN ANIMATOR MUST KNOW ACTION, FACIAL EXPRESSION, AND BODY MOVEMENT. HE MUST BE ABLE TO USE HIS KNOWLEDGE TO CARICATURE LIFE, DRAMATIZING THE FEELING OF THE PICTURE AND BUILDING IT INTO AN INTERESTING STORY.

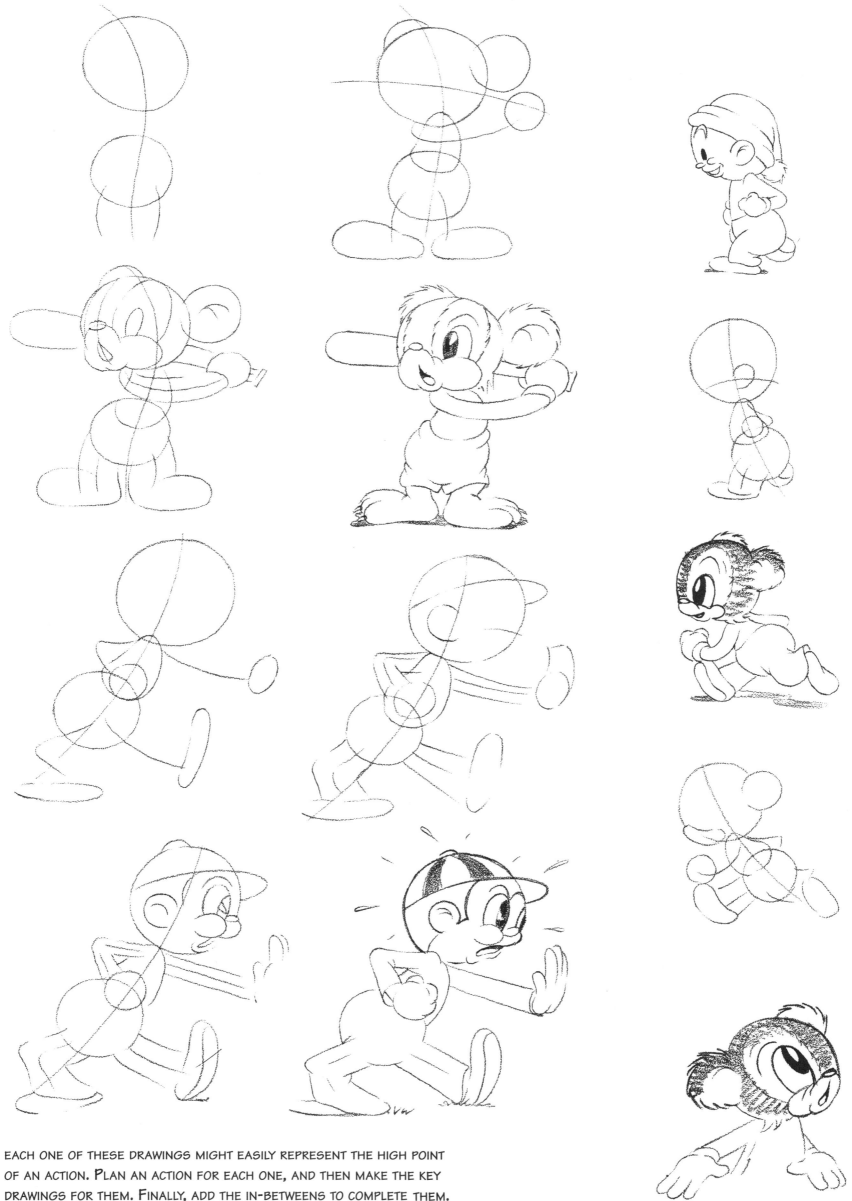

EACH ONE OF THESE DRAWINGS MIGHT EASILY REPRESENT THE HIGH POINT
OF AN ACTION. PLAN AN ACTION FOR EACH ONE, AND THEN MAKE THE KEY
DRAWINGS FOR THEM. FINALLY, ADD THE IN-BETWEENS TO COMPLETE THEM.

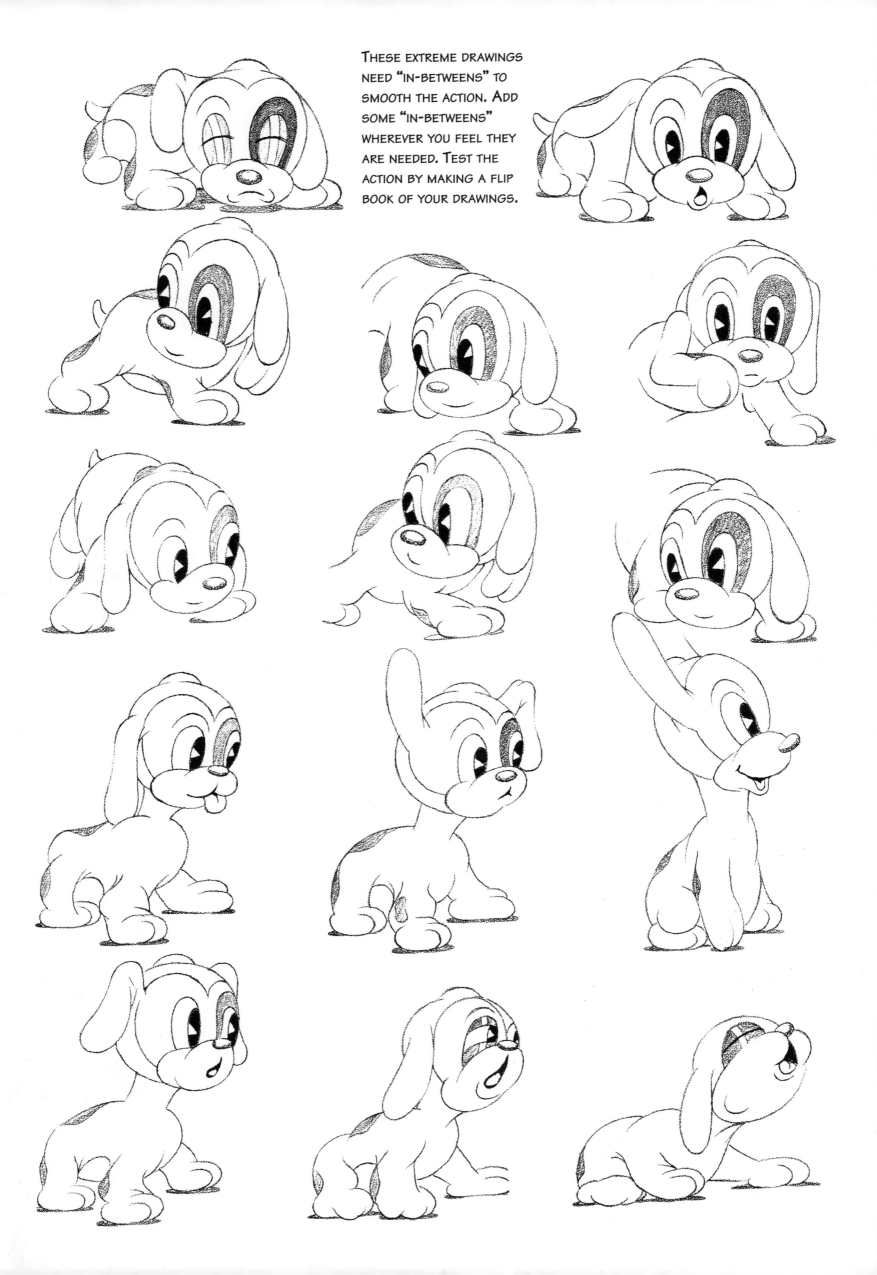

THESE EXTREME DRAWINGS NEED "IN-BETWEENS" TO SMOOTH THE ACTION. ADD SOME "IN-BETWEENS" WHEREVER YOU FEEL THEY ARE NEEDED. TEST THE ACTION BY MAKING A FLIP BOOK OF YOUR DRAWINGS.

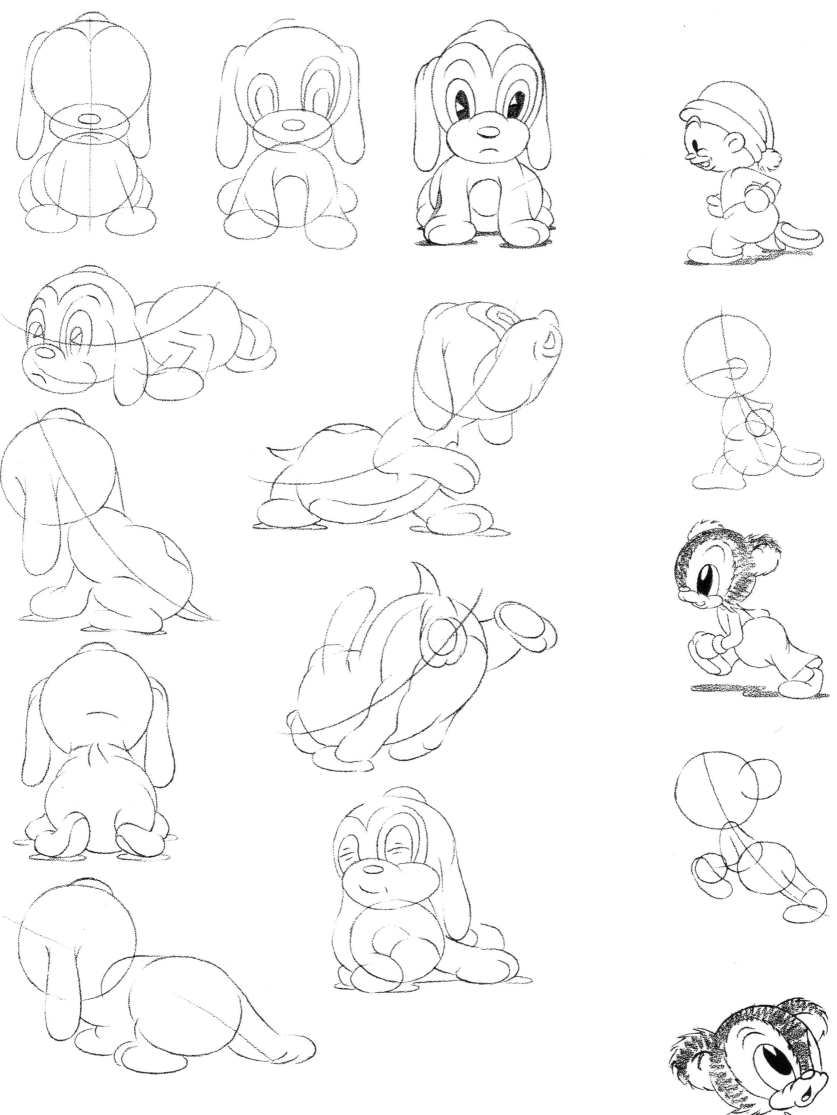

STUDY THE DIFFERENT POSES OF THIS LITTLE PUP. THEN
USING ANY TWO OF THEM AS "EXTREMES," DRAW THE STEPS
IN BETWEEN TO CREATE AN ACTION. THESE ACTION DRAWINGS
WILL HELP YOU DEVELOP YOUR ANIMATION TECHNIQUE.

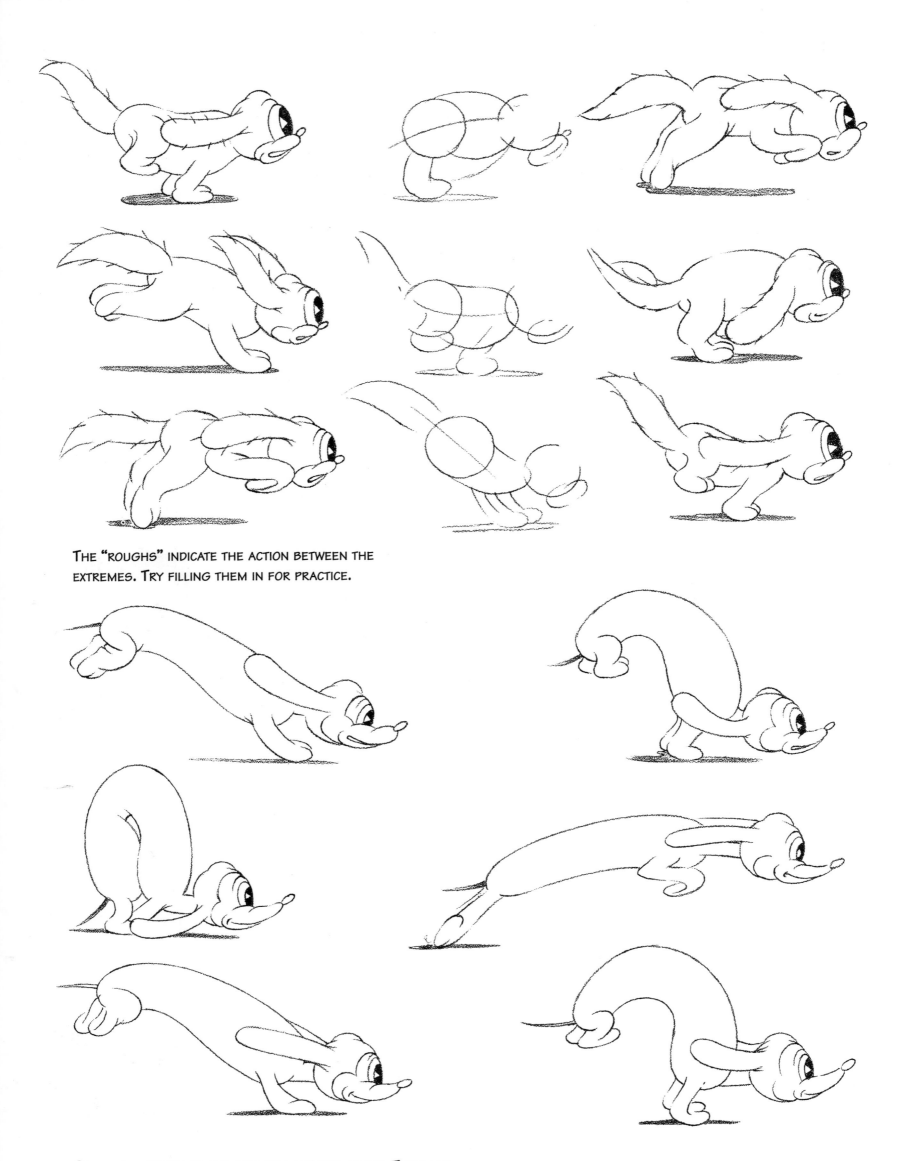

THE "ROUGHS" INDICATE THE ACTION BETWEEN THE EXTREMES. TRY FILLING THEM IN FOR PRACTICE.

STUDY THE ACTION OF THE TWO RUN ACTIONS ABOVE. THEY ARE ANIMATED AS STRAIGHT ACTION AND, IF SHOWN ON A MOVING BACKGROUND, THEY WOULD BE A RATHER FAST "PAN" ACTION.

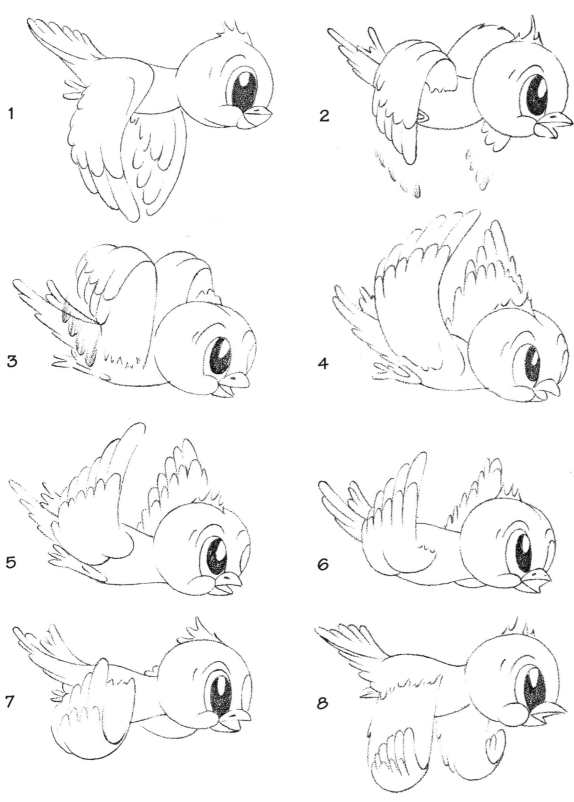

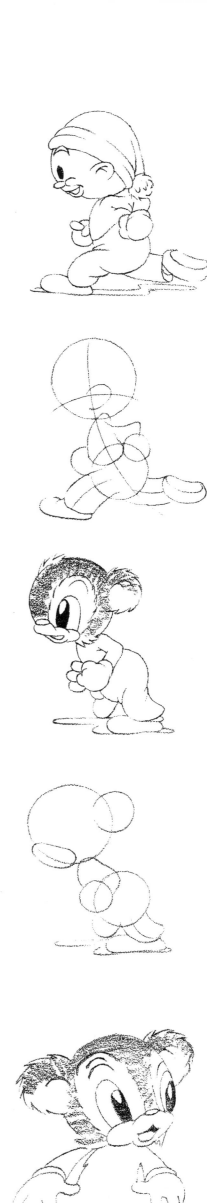

THE CYCLE FOR A BIRD'S FLAPPING WINGS USUALLY TAKES FROM EIGHT TO TWELVE DRAWINGS. DRAWING NUMBER ONE FOLLOWS DRAWING NUMBER EIGHT TO CONTINUE THE ACTION. THE TWO "EXTREMES" IN THIS WING MOVEMENT ARE DRAWINGS ONE (LOW WING POSITION) AND FOUR (HIGH WING POSITION).

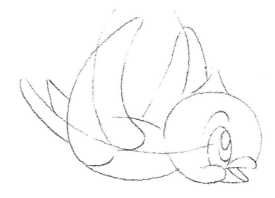

THESE ARE THE ROUGHS FOR CONSTRUCTING THIS LITTLE BIRD.

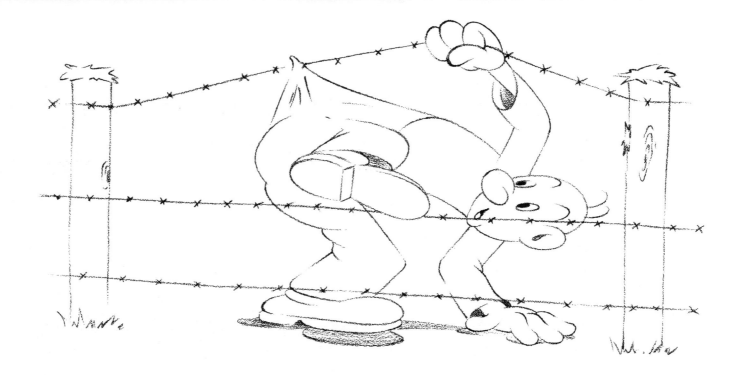

These are the types of problems that the leading studios give their animators to solve...Try them!

The problems on these two pages should be executed without the use of models or photographs. Make each drawing on a separate sheet of standard size typewriting paper using HB, B, or 2B lead. Do not mat or staple your drawings.

Problem 1: Visualize a man encountering difficulties climbing through a barbed wire fence. Draw your reactions in several poses. Try to inject humor and character into your drawing.

Problem 2: Use the same procedure to draw a tall, thin man rowing a small boat. Try to keep the scene interesting.

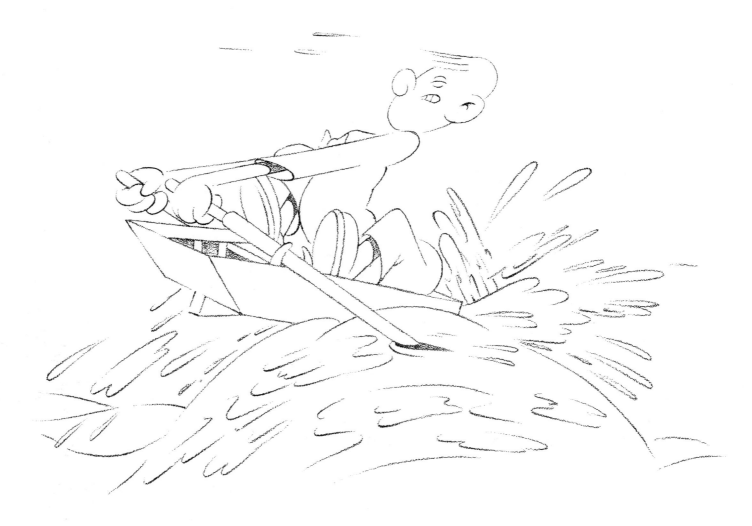

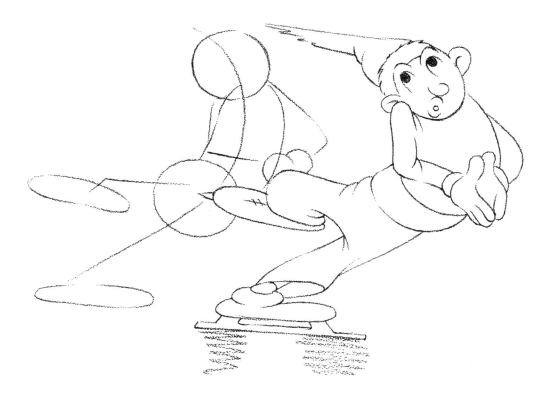

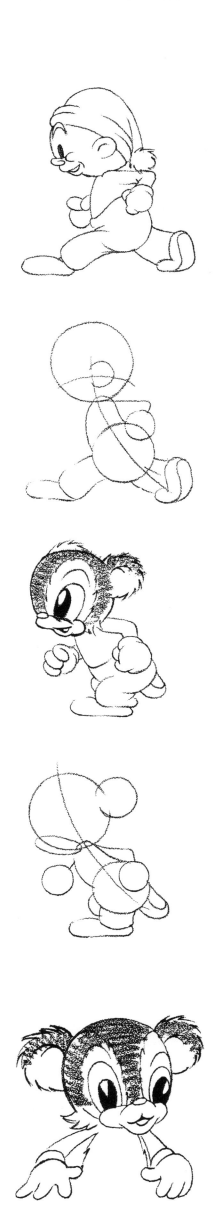

Problem 3: Make three or four drawings of a comical situation involving a man and a woman either ice or roller skating.

Problem 4: Caricature the action of a large man working in a shallow ditch. Build the situation to its most humorous point. Be sure that the idea is cleverly portrayed and that your drawings express action.

Now that you have practiced the exercises in this book, develop some characters, write a story, and animate it. For further reference, see Walter Foster books #26, "*Cartoon Animation*," and #190, "*Film Cartoons*," both by former Disney animator Preston Blair. Good Luck!

—Walter T. Foster

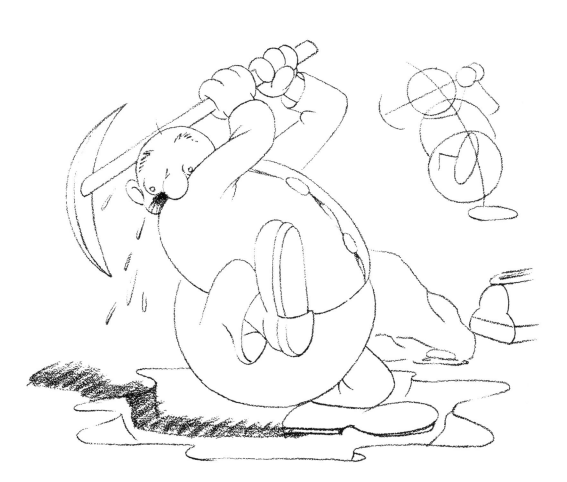

More Ways to Learn

Artist's Library

The **Artist's Library** series offers both beginning and advanced artists many opportunities to expand their creativity, conquer technical obstacles, and explore new media. You'll find in-depth, thorough information on each subject or art technique featured in the book. Each book is written and illustrated by a well-known artist who is qualified to help take eager learners to a new level of expertise.

Paperback, 64 pages, 6-1/2" x 9-1/2"

Collector's Series

Collector's Series books are excellent additions to any library, offering a comprehensive selection of projects drawn from the most popular titles in our How to Draw and Paint series. These books take the fundamentals of a particular medium, then further explore the subjects, styles, and techniques of featured artists.

CS01, CS02, CS04: Paperback, 144 pages, 9" x 12"
CS03: Paperback, 224 pages, 10-1/4" x 9"

How to Draw and Paint

The **How to Draw and Paint** series includes these five stunning new titles to enhance an extensive collection of books on every subject and medium to meet any artist's needs. Specially written to encourage and motivate, these new books offer essential information in an easy-to-follow format. Lavishly illustrated with beautiful drawings and gorgeous art, this series both instructs and inspires.

Paperback, 32 pages, 10-1/4" x 13-3/4"

Walter Foster products are available at art and craft stores everywhere. Write or call for a FREE catalog that includes all of Walter Foster's titles. Or visit our website at www.walterfoster.com

Walter Foster™

Walter Foster Publishing, Inc. • 23062 La Cadena Drive • Laguna Hills, CA 92653 • (800) 426-00